Also by Lazarus Finch

Back to Black

Fantasies and Nightmares

Where to Find Lazarus Finch:

On Instagram:

https://www.instagram.com/lazarus_finch_a

uthor/

On Facebook:

https://www.facebook.com/LazarusFinchAu
thor/?fref=nf

Email: Snap314@gmail.com

BREATHE AGAIN

By Lazarus Finch

Copyright 2019

Author's Note: this is a work of fiction. Names, characters, places, and incidents either are the product of the author's imagination or are used fictitiously, and any resemblance to actual persons, living or dead, business, establishments, events, or locales is entirely coincidental.

Table of Contents

Preface

I want you to know, should you find this book and take the time to read it, you were a huge inspiration to its creation. Parts of you (us) have been scattered and permanently written across these pages, ensuring you and I and those moments we had: they'll live on well after we've ceased to be.

That time will never be forgotten, and I think this book will be that everlasting shrine to what we left back there; that snapshot of love, captured and stored within this collection that'll serve as an album of what could've been between us had circumstances been different.

I also want to believe you're out there—and as much as it pains my heart to imagine you've found love in the arms of another—having tender kisses planted on your forehead, on your supple and luscious lips, and a pair of

roaming, desiring hands pulling you in close from the madness of this cold, unforgiving world.

Craving, lustful fingers intertwined 'round your curvaceous hips, pulling you covetously into your lover's warm, caring embrace with all the sense of unification between two separated souls having found their missing half: a reunion that goes beyond the body; stretches further than the material realm, and completes us on a level seldom recognized for the spiritual wonder that it is. I want you to find that stream and drink for its banks, beautiful. God, I hope you find that.

I could've gone there with you hand in hand, but life doesn't always bend to our whims, baby.

I imagine your eyes—which were, when I'd look at 'em, hypnotic—staring into your lover's mesmerized gaze with this terrifying, completely justifiable sense of vulnerability. But it's Ok—that rapid heartbeat on your end, it's all for naught 'cause *that* love is reciprocal.

This time, you can say it and revel in the fantastical possibilities afforded two hearts having become one. Don't be afraid to tell him; just say it and watch his lips mouth those very same three words: I love you.

I want you to feel that love in your heart that has so often times slipped through my fingers, even if it won't be coming from me, darling.

I would never want you to walk around not knowing a sensation that makes you want to sing, dance, smile, or have a reason to feel as if the world is worth waking up to, because love in our lives can lift us out of life's nightmares with the simplest of gestures; a morning text; an unexpected bouquet of flowers sent your way on a chilly winter evening; a foot or back massage after a stressful work day—there's plenty of ways to show a sliver of love without emptying one's bank account, just takes a little effort. I want you to have that, and I know you will.

You told me to write about us someday, and I believe this collection has parts of our brief time together woven into its spine, just take a look, hon.

Despite the "graphic" retellings of sexual encounters, there's an underlying message to it all that's distinct from the lust. The sexual intensity notwithstanding, there exists a passion here that is infinitely greater than what are bodies crave when everything below the navel burns with a fierce, unrelenting wildfire that dares to scorch every inch of our loins, if no one is around to help douse these frenzied flames with a pair of wet, soft lips. Read between the lines, it's an ember yearning to be teased into an inferno.

Erotica seems to be stigmatized as "smut," when the art itself is in the reader's ability to look at the material with an adult's mind, and a keen security within their own sexuality. It isn't for everyone, in more ways than the content written down.

Since my first sexual encounter, I took mental notes on what I was doing right, and paid closer attention to the techniques that didn't quite satisfy.

I wanted to learn to please a woman; to leave my partner feeling as satisfied as they've ever felt before in matters of sex, (with a titillating mixture of pain and pleasure sprinkled in for a heightened orgasm; leaving her body convulsing on the bed as she climaxes, her upper thighs spasming in bliss, her glazed-over eyes rolling towards the back of her head as her velvet sheath releases its last droplet of sweet nectar).

A balance had to exist if certain sexual, orgasmic heights were to be met. Life is too short and fragile to spend a minute in bed with a lazy lover. Personally, I've had a few, and it was awful.

Some just stayed on their back during the entire time, even if I gave a "cue" to switch positions, they'd just stay flat on their back like they'd been Krazy-glued to the

bed, or floated to the top of the aquarium belly-up like a dead goldfish.

Others didn't enjoy anal—had a painful experience at some point with a brutish, unexperienced partner, or just weren't interested in trying anything backdoor related; no fingers, no tongue—so I felt deprived, and, ultimately, bored.

I am selfish, but who honestly isn't?

I don't want to eat the same meal every night of the week; which is why sexual compatibility is vital in adult relationships. Communicate, *honestly.*

I like variety; something different at least once or twice a week, otherwise it becomes predictable and stale. It becomes painstakingly redundant, like a song on loop that's driving you insane.

If you can diagram what your partner's next move will be, like a choreographed dance move, where's the excitement and "hunger" in that encounter? If you know

the ending, there's no point in buying a ticket to see the beginning, that's just my take on it.

And, because the average human being is conveniently self-centered, their self-serving actions express themselves (badly) in bed—it's only logical.

Besides, ladies, would a pinky or tongue up your asshole really send you to the emergency room?

At what point is it that you're actually just self-conscious about a part of your body you're not entirely sure is "thoroughly" clean? You're petrified it could smell like shit back there (let's be "real" with each other, we're not kids anymore), or your guy might pull his finger or cock out of your asshole with a little Hershey's Kisses on the tip.

Simple solution: CLEAN YOURSELF well.

That means not just skimming the bar of soap lazily between your ass cheeks, hon. CVS has enemas, figure it out.

But many women, especially the younger ones (at least the ones I dated), can't be bothered to put a little effort into the encounter, other than getting on their back and dividing their legs. Yawn. If that's all there is in your world to having sex, God bless you and have a wonderful life, George Bailey.

Once I moved past women in their early twenties, and met older women with experience that weren't selfish lovers (or not *as* selfish as their younger, quasi-clueless counterparts), the level of maturity and sexual assertiveness was refreshing. I mean, Christ, these younger women thought being kinky meant blowing you in the shower, or doggystyle in the kitchen while she's searching the fridge for her Pumpkin Spice chai latte concentrate.

Good God.

I felt at odds—as well as terribly disappointed and disgusted—by the "viable" female candidates available in this cesspool known as Brooklyn, New York.

11

Jesus on a frosted flake, it seemed as if *every* woman I met along my path of growth had a mental and emotional affliction of some kind.

And for some, it literally was evident on their bodies; self-harm, leaving scars behind on their forearms from cutting, or on their thighs from burning themselves with cigarettes. Others had issues with drugs, with alcohol—a carousel of human garbage bags that I routinely kept picking up, only to toss right back to the curb after realizing there was nothing to the adage: *"one man's trash is another man's"* They weren't interested in breaking these self-destructive habits, only nurturing them while ironically killing themselves. I wanted no part of it.

There was a significant maturity gap between myself and these "green" women.

I felt I was in a sexual relationship with someone a couple of decades my junior, and that's an irreversible turn-off. They were raw on many life issues unrelated to sex, but

somehow felt as if they were intelligent because they graduated college, or had a "professional" job to hang their hat on.

Their attitudes—who they were overall—left me wondering why I'd bothered to date these women, let alone sleep with them. I was repulsed by plenty of them, but still, I succumbed to my sexual needs and took quite a few for "the team."

Dating in my early twenties I realized, disappointingly so, women near my age or younger were simply immature in not just matters of sex, but across many facets of life.

I began studying them, asking questions of their upbringing—anything that could give me insight as to how they became the woman standing or sitting before me—and, from what they revealed, saw exactly where the differences between us had been casted.

I was older than my numerical age, and it showed when we'd meet-up, much to my disappointment. I tried to understand that these women were simply byproducts of their parents' coddling and sheltering measures, so their vantage points of the world, let alone how sexually empowered they were, was extremely and comically limited.

I remember one girl—we'll keep her name off the record—attempting to blow me by "pecking" at my cock like it was chicken feed, from between my legs while on her knees near the edge of the bed. What. The. Fuck. I looked towards her, saw what she was doing, and immediately decided right there *this* was our last day together. There's no coming back from this idiotic visual of an adult woman pecking at my cock like a farm animal.

Done.

I'm irreversibly turned-off. I asked God for a favor while she was down there practicing her chicken bit,

something small—not *too* big: to have her fall off the bed and crack her head against the wall, hoping the head-to-drywall crash would flip a switch on her brains and she'd come off airplane mode.

Stupidity is a major turn-off. Going at my cock like she was bobbing for apples at the county fair.

Good grief, Charlie Brown.

I learned more from older women; seasoned souls that had experienced more of life, some wearing those figurative scars along their body. I could read it in the crow's feet across the edges of their eyes; in a wrinkle or two along the ends of their lips, or the fading light in their tired eyes—they had stories to tell, narratives hoping to be read by a genuinely curious pair of eyes.

In time, things changed. I finally met people that could understand elements of who I am, because they'd been through some rough shit, too.

They were honest with me, and I listened to them when I'm sure many hit the internal mute button when these scarred, exhausted souls candidly spoke about their life's journeys.

And I'm grateful for their frank communication and patience in showing me certain sexual techniques that, not only worked on them, but would also bring pleasure to other women, too.

Again, some of those encounters are awaiting you in this book, so dim the lights and make yourself comfortable.

I want to thank all of the women—the not-so-bad *and* the entitled assholes—in my past that made this book possible: thank you, ladies.

Even in the worst of times, I had the presence of mind to realize there was something to be gleaned and extracted from these failed, toxic relationships, even if it was mostly sexual and nothing more.

I also want to thank the female singers who inspired my mind to venture towards the sensual, the sexual, and, above all else: the artistic. To not only realize the power of sexuality, but also its place in our lives and the arts if done "right," and with just as much passion as the actual act of sex.

Sade, Toni Braxton, Madonna, Samantha Fox, Norah Jones, Lana Del Rey, Leona Lewis, Joan Jett, Whitney Houston, Erykah Badu, Paula Abdul, Martika, Alicia Keys, Stevie Nicks and Amy Winehouse: these lovely souls inspired my mind with their form of art, and I'm forever grateful.

Devilish Delights

She stepped into the bathroom, the cold tiles beneath her

feet chilled her to the bone,

Wearing only her lacy pink thong with the elastic band

coiled 'round her voluptuous waist,

She couldn't wait to slide them off, to submerge her tense

body within that hot bath and pleasure herself to the scent

of his arousing cologne.

Her thumbs slid underneath that pink band, she bent

forward at the hip,

Peeling off her panties seductively—as if he was behind

her, watching her light the flame that'll spark an ember of

passion within his groin,

She looked back imagining her voyeur rubbing his

hardening cock in admiration, and at this fantasy, our

curvaceous femme fatale bit her lower lip.

Tossing the wet thong into the hamper—thoughts of

animalistic sex throughout the day kept her moist and

anxious—anticipating this moment with a bottle of

Merlot, candles, and her vivid fantasies at play,

She placed her right foot within the menagerie of bubbles,

the water was hot—ahhhh!—finally she can relax after

such a long, hard day.

 She wriggled her body into a more comfortable

spot, the half full glass of Merlot resting on the edge of the

tub, the candles—four placed along each corner of

marble—flickered with a sensual, erotic flame,

She reached forward and turned off the valve of hot water

that fed the tub, grabbing the handheld extended chrome

showerhead she'd use liberally as she'd moan his name.

 She brought it towards her neck; depressing the

showerhead over both sides of her stiff clavicles—

imagining each warm plop was his lips teasing her;

readying her for a tsunami of unseen pleasures—her left

hand gently began caressing her supple breasts,

Her nipples fully hard at the mere thought it was his fingers

faintly grazing her pink nipples,

She began venturing farther down below—her legs

dividing in famished straits; a void seeking maximum

fulfillment—her left hand's index finger made contact with

her throbbing clit as her heart began racing within her

chest.

Her fantasies began to veer towards the deviant;

imagining his tongue descending—in a tantalizingly slow

spiral 'round the bend of her neck—and down the rigid

curvatures of her sleek spine,

Each loop of knotted flesh and firm bone presents a

rollercoaster of erogenous zones his mouth and tongue

taste, they savor for each bump and curve they present: this

whirlwind of sexual bliss she conjures in her lustful mind.

Her pussy is wet—but the water in the tub is not at fault—

she's been busy rubbing her slit,

The showerhead depressed over breasts further adds

gasoline to the inferno raging between her legs,

She imagines his tongue is taking long licks from the top of

her ass crack, to the tip of her clit.

She raises her ass higher off of the floorboard of the

marble tub, dropping the showerhead in favor of spreading

open her right cheek—the index finger of her right hand

finds her tight, puckered asshole aching to be filled,

It's at this point she began fingering both holes beneath that

armada of bubbles and steam,

She was the architect of this fantasy, but how she wished it

was his probing hands filling her to no end, a lover that was

just as debaucherous and equally as skilled.

Knuckle-deep into her wet, tight holes—that's how

she loved it, the candles burn fiercely; their shadows

danced and reflected off of the walls as she dared set the

waters on fire,

Her creamy pussy seemingly drowning in a torrent of

carnality; her asshole stretched and filled beyond her

animalistic desires.

Oh, how she loved double penetration—at least the

fantasy of having both holes fed at the same time,

How she never spoke openly of such fantasies for fear of

being labeled a slut,

So instead she kept it locked and arrested to the confines of

her perverse mind—as if indulging in one's desires was an

illegal and immoral crime.

The bubbles burst as her hips jerked and contracted;

the stimulation of both holes at once was much too great

for her to bear,

Her fingers slid into both holes easily; the cream from her

pussy being used as lube for both; front and back, she

fucked herself emphatically on this night without a single fuckin' care.

Sliding her index finger out of her asshole, she wrapped her lips around the creamy digit that had given her much sexual bliss,

She imagined her invisible voyeur was now jerking off furiously seated on the toilet while watching from afar, and so she got on her knees—arching her back and positioning her ass towards his line of vision—before blowing him an inviting, and teasing kiss.

Now she rubbed her swollen clit faster, using her free hand to spread her left ass cheek open—'see anything you'd like to fuck? Where do you want to slide it in?'—teasing herself and this invisible man,

She fantasized his face was now buried between both of her robust cheeks; tongue-fucking her aching, barren holes as she held up her convulsing body under two trembling hands.

She rubbed faster.

She rubbed harder.

She was about to cum, but she wanted him to slide

his cock from her slick pussy, and ease it into her puckering

ass,

She wondered if the cream from her slit was enough to aid

in the onslaught of her rear entry, if it'd help prolong this

dream longer than it'd take her to swallow the contents that

remained in the wine glass.

Swallow.

She had wanted to—to taste his cum; was it sweet

or sour?

But it'd been awhile since she'd felt a man explode in

ecstasy within the tight, contracting muscles of her

sphincter,

So she grabbed his cock from behind, aligned it with the

opening of her asshole and impaled herself upon it till his

balls were pressing against her plump clit: she took all of
him with barely a whimper.

She rode it.

Rode it steady—full tilts, slowly and then fast-
paced; imagining his full shaft had vanished deep within
her backside—until he was ready to burst like a dam under
too much stress,
She rubbed her clit till her wrist began to ache, ignoring the
plea to at least switch hands, she massaged her pussy like a
nympho possessed.

He was on the cusp of an explosive climax—and so
was she, the candles shooting flames of delight, the glass of
wine knocked over towards the floor,
He burst a warm load of cum deep within her ass while
claiming her as his nasty whore, as she came as well only
to beg him for more.

The fantasy had ended, the phantasm had disappeared just

as quickly as he had appeared in that bathroom of delights;

a ghostly voyeur of such lascivious and deviant sights,

She placed the chrome showerhead back on the adjacent

hanger, stepping out to dry her freshly "baptized" pussy,

having found that angels often times find greater

satisfaction when indulging in these devilish delights.

Just a Fantasy

It was the last personal training session between us, and I'd be lying if I said I had no idea—or even the slightest imaginings—that there was a thick, heated and palpable air of sexual tension between Amanda and me.

It was there, I just wasn't sure if either of us wanted to acknowledge it.

I heard it in her laughs when I'd tell a corny joke that no one else found the least bit hilarious.

I saw it in how the irises of her eyes radiated with scalding desires when I'd show her how to properly lift something, and my biceps bulged as the muscles contracted; the veins filled, pulsating with blood like snakes slithering underneath the skin wound taut around my arms.

I sensed it in her pained groans as she'd squat down with the barbell draped across the back of her shoulders,

and as she'd rise up, those groans becoming a faint moan as her round ass would temptingly graze the head of my cock over my windbreakers—spotting her had skyrocketed my blood pressure, as both of us now head quickening heartbeats and beads of sweat along our brows.

I'd always feel the blood flood towards my groin when it was leg day and I saw Amanda coming towards me, eager to engage her lower body workout, while I tried my best to keep my eyes off of her newest tights that appeared to be nothing less than a painted on panorama of bright colors on a canvas of curvaceous flesh I ached to savor.

To taste this forbidden fruit.

Her ambrosia.

I'm not sure if she could read my poker face, but then again, I was awful at card games that required masking one's hand.

I suppose that's why I went to her home for that last session, calling her bluff . . . calling my own.

I knocked on her door at twenty past nine that evening; a balled-up left hand knocked just loud enough to alert her I was outside, not loud enough to bring attention from any neighbors nosing around their windows or walking their mutts one last time for the day.

I was slightly wet from the rain that hadn't let up since I got off the train and walked over to her place, but she wasn't that far from the station.

It gave me some time to think.

To fantasize.

Amanda lived six blocks away from the crummy train station, it only seemed longer 'cause the weather was conspiring against us and this later than usual training session.

This rendezvous that, now that I put into context with past clues, kind of wasn't as mysterious and innocent as I wanted to fool myself into believing.

I wanted to fuck her.

There was no doubting that.

With those eyes and that body, I'd be castrated and lobotomized before passing on an opportunity to know what it was to make love to this divine angel of a woman.

And to find out just how devilish she'd be within four walls, a door, atop a bed, and enveloped in the anonymity of darkness where creatures like us are allowed (expected) to remove our societal masks, if only to indulge in the feasts of our carnal desires, would be heavenly.

To be what nature placed within our DNA, and what civilized society aimed to conceal and shackle for its own benefits.

I wanted to remove it all—not just my clothes or hers, but these false pretenses of what we're not or aim to be just to fit in as a spoke on the wheel.

Again, I wanted to taste Amanda's flesh; the tart of her sweat, the candied honeypot she kept in between the folds of her legs: I had to taste it all.

And I could only do so if she was true to what she was, or what I had presumed she was: a demoness wearing a crooked halo and snap-on wings.

When she answered the door, I sighed internally as my brown eyes scanned her quickly and already I could feel my cock begin to swell in approval of her clothing, of the tanned mounds of soft and succulent landscapes of flesh the tips of my fingers, the palms of my hands, the tip of tongue, and my hardening cock ached to indulge and ravage.

Till our bodies were exhausted and our hips quivered from the multitudes of mind-numbing orgasms, this was my fantasy.

She wore a sports bra—her C-cups barely contained, slopes of her cleavage teasing me into a maddening feeding frenzy.

Cujo came to mind—the rabies infected dog from a great Stephen King novel.

At that moment, I felt I could relate to that mutt foaming at the mouth in rabid heat wanting nothing more than to sink its fangs into a hunk of warm meat.

Her tights were black, which is pretty common with women working out, but these clung to her skin like a second skin, so if she bent over, I'd get a clear look of what's under this early Christmas gift.

Her pink Nike socks were rolled down to her ankles—how I wished those were her tights instead.

She kept her hair tied back tied tightly in a bun, but it hung down to her scapula when it was free and loose.

She dyed it blond recently, her dark roots were starting to sprout like horns revealing her true dark nature. I told her I just needed to freshen up before we'd start, making my way to her bathroom to dry up, to give my cock a breather.

Amanda was in her living room stretching, having cleared out more than enough space for us to warm up and get the blood flowing.

It started to flow for me when she began stretching out her spine and was on all fours doggystyle.

I had parked myself behind her, trying way too hard not to look, but I couldn't help it.

I couldn't suppress my inner hunger—that insatiable beast climbing towards the hilt of my throat, lookin' to pry my mouth open from the inside so I'd just feed it like our primitive ancestors had done.

But I just watched Amanda stretch, her tights expanding till bare flesh could be seen in stretched-out gaps of spandex and lycra, these craters of skin all conniving to charm my snake from out of its hiding place and into the open air of Amanda's living room.

Amanda leaned back, fully arched with the right side of her face flat against the mat, my eyes locked on where I could've sworn I saw her pussy lips being flossed by the pinkest thong I'd ever seen in my life.

My cock began to hurt from the massive erection that she'd built with this risqué show of passive aggressive sexuality.

When she asked me to come closer and feel her hamstrings, see if they were too tight, I'd nearly came in my cotton gym shorts.

I ran a hand over them gently, yet firm enough to assert my confidence in the situation as not just a trainer, but also a possible lover.

Amanda asked me to stop being so shy, to come up higher where she'd felt something tighten.

My right hand was under her upper thigh, towards the insides of her legs and directly under her pussy now.

I could feel the heat emanating from her honeypot, and it drove me wild with sexual excitement.

My cock was throbbing with every second ticked off that I hadn't pounced on her.

She asked me to massage her inner thigh, to work my way towards the backs of her legs slowly while she held her doggystyle position.

I did as I was told, and as she moaned, I lowered my head towards her ass and took a deep breath, inhaling her feminine scent.

My cock hated me, swelling with frustrated pain.

My balls felt like two mass planets being brought together by an unseen gravitational pull (Amanda's ass in

my face), and I took one hand away from massaging her hamstring so I could massage my own stiffening muscle.

Amanda's head was turned away, and with her moans signaling to me she was in a state of bliss, I took an educated guess that she wasn't watching me, just feelin' me in a sense.

I stroked my cock slowly over my shorts, then, after inhaling her scent again over her tights by the back of her ass, I began to run it over its length in full, firm tugs.

I zoned out.

I zoned out like an idiot just long enough to be caught.

Amanda caught me, but it was what she said after the fact that shocked me stupid above all else: take him out.

Amanda wanted me to take it out.

I had no words, only actions.

And actions speak louder than words, so I took him out.

I got up on my knees, still bent behind her exquisitely round ass, and flipped my cock out through the waist band of my shorts.

Lower them she asked, and so I did.

She stayed on all fours, but rose her face off of the mat and looked over her left shoulder with her hands still propped on the black silform mat.

She hooked her thumbs by the sides of her elastic waistband, smiled at me this mischievously dangerous smile, and began to lower her black spandex tights till they came to rest right below the clefts of her heavenly humps.

These mountains of tanned ass cheeks that had the thinnest pink string nestled in between 'em, both tight holes barely concealed by this cotton candy-like lace.

I wondered if it'd melt on my tongue.

Take it she said, and with that, she used the index finger and thumb of her right hand to pull her thong to the side.

Her asshole was invitingly pinkish; the rim appearing to be tight enough to drain a man's cock of every ounce of cum in his sack well before he intended to bust his load.

The strips of her wet, glistening pussy were lips of candy I dreamt of kissing on many nights after we'd workout together, and I saw that pocket of flesh stare back at me when she'd do hack squats or hip adductors.

The machine at the gym dubbed the Good Girl.

But here was Amanda, being the Bad Girl.

I took it.

I placed my hands on both of her meaty mounds.

My lips kissing both cheeks softly, a stark contrast at how I felt within, but still, I didn't want to scare her off.

Not now.

Pace myself.

Enjoy myself.

Savor her.

My tongue began its descent at the crack of her ass, and slowly sloped down till it came upon the puckered rim of her asshole, where I swirled it over in a clockwise motion, tasting and savoring that pinhole sized opening.

After one full twenty-four hour cycle, I went twelve-to-six and slid it inside her ass, till I had every inch of my tongue deep in that clenching band.

I heard her moans, her panting, her coos to go in as deep as I can, tongue fucking her ass; darting in and out of that tight ring, and savoring the taste of this forbidden fruit.

She reached back, dug her nails in the curls of my dirty blond hair, and leaned her ass as far into my face as she could, till I could only breathe the scent of her sex.

Her asshole puckered; soft *pops* as it dilated and contracted under her control . . . she was teasing me, weakening me.

And I fucking loved it.

It was fucking sexy, how her halo had fallen off with a thud and these horns sprang up in its place.

I wanted it badly.

She pulled her ass away, lowered my head with that hand, and brought her pussy towards my mouth.

That cream—glazed my face like a doughnut in seconds.

I had a sweet tooth that needed tending to.

I divided those lips with my tongue, slurping up every ounce that spilled out of her as if I'd been deprived of these juices all of my life.

And I didn't intend to go without them any longer. I pulled her hips in closer, till I had no real estate left on my tongue to give her pussy the workover she desired of me. I tongue fucked her pussy till she was on the cusp of bursting, using my thumb to rub her clit feverishly.

I spanked her ass hard when I felt she needed to be tamed; the tigress 'bout to leap out of her cage and maul

unsuspecting passers-by, but her claws and bite and glare never to be domesticated.

Always to be wild and savage when the mood required nothing less of her.

Without that duality of yin and yang, she'd be awfully common.

She'd be less appealing to me.

I ran my tongue in and out of both holes; tonguing that asshole which popped softly when I'd remove it (a sound that left me wondering how airtight that seal would be if my cock eased itself up her ass), and back to her pussy then right back to her ass every other second.

A spank here, I'd claw her lower back there—she shuddered with sexual fever anticipating the next dose I'd give her.

Fingers began sliding in and out of her viselike grips for holes, the sound of sex filled that living room.

The mat was wet with sweat, cum, and indentations of two bodies feasting on the other as if each were an all-you-can-eat-buffet.

And I was starving, so there'd be no price I wouldn't pay to devour this woman tonight.

I heard her, asking me to let her cum or she'd scream from the pent up flood collecting in her hips.

I said no, not yet.

I rose up behind her, still on my knees and aligned the head of my cock to the entrance of her dripping, warm pussy.

As I guided it in, the head barely vanished into those two velvety drapes before Amanda sighed like the levee had come crashing down, and she'd flood the living room at any moment.

I used the thumb of my left hand to finger fuck her asshole, while my right hand hooked into her hip and propped her up higher like when she first began teasing me.

I must have fucked her pussy for no more than ten minutes before she shouted something about her asshole.

Fuck my asshole!

Do it, goddammit! Take it!

I see—daring me, huh?

I liked this game, so I pulled him out of her pussy, completely covered to the balls in her milky white cum. I didn't need lube, not with all of that cream coating my cock.

I massaged it evenly along the length as if it were a rich, homemade lotion, tasting some from my index finger and sighing in approval as I swallowed it.

She leaned back, lowering her ass to meet the head of my cock.

I rubbed the head against her asshole, teasing her, jabbing at the exit that'd soon be my entrance.

She panted like a child, asking me to stop teasing her, trying to impale herself on it, but I'd pull it up or down— avoiding her asshole's vain attempts to ride my cock.

Till I rubbed it on her asshole one final time and she caught me by surprise.

A good surprise.

She leaned back just as I jabbed at it and more than half of my hard cock vanished in that pink, tight fucking asshole.

I nearly came without having thrusted once . . . it was surreal.

It was orgasmic.

It was just a fantasy.

Tigress

I wanted to flip you over; savagely place you face-first

against that wall with your legs spread wide open,

I wanted to rip your blouse off and toss aside your bra;

revealing your voluptuous breasts—these fantasies of ours

seldom spoken.

To press my groin in-between the crack of your

curvaceous ass; I know you can feel me jabbing at both of

your entrances from the outside of your tights,

To lower myself to my knees and plant my face squarely

in-between those cheeks; inhaling your feminine scent, how

I wondered about you sexually all those sweltering summer

nights.

I imagined you smelled divine; but your holes were

wet—God, you're such a devilish little tease!

I just want to rip off those angels wings, throw you on this bed, demons doing away with our halos with the simplest of ease.

Turn over onto your stomach, now prop yourself up on your knees—arch that back higher and give me a good view,
I want to pass my tongue over both of your warm, wet holes— fucking them both until I leave you senseless, an orgasm that is known to but a few.

I spread your mountainous cheeks far apart; both slits anticipating my tongue, you pull me closer by my hair,
Riding my tongue till your orgasm as at a near crescendo, my cock pulsating as I align it with the opening to your ass—this is all I can bear!

OHHHH! How tight you are, Jesus! I can feel your 'grip' along every inch of my hardened shaft,
I reach around to rub your aroused clit, I must pace myself and savor this moment if I'm to ever last.

Your hand reaches under, grabbing at my balls; squeezing

them in amorous heat,

You're like the tigress I had envisioned, instructing me to

lie on my back as you mount my hardened cock; riding my

prick as if it was a bicycle seat.

Up and down, up and down, faster, slower—I'm

about to cum a warm, hefty load in your asshole,

You scream for me to pull your hair harder, to squeeze your

breasts intensely, I climaxed so wildly we both fell to the

floor, having lost that innocence of our once pristine souls.

That's where we awoke the following day,

mischievous grins embedded across both of our faces.

You tigress.

You lured me straight into hell.

Halos were never my thing.

Cum Closer

Your hazelnut eyes tell a story; nothing obscene, simply a tale of places your body has been.

Those shapely curves turn this otherwise mild-mannered man into something quite predatory; the saxophone's sultry sine waves add to the sensuality of this serene scene,
as in my head I've already begun undressing you wildly—my dirty thoughts wondering if there's anything you've not seen, any part of you that still remains clean.

Those strands of sable resting delicately upon the mid-point of your cream-colored back; I caught a whiff of that mane the moment you crept by the foot of this bar,
Imagining how it must feel to pull a handful of those tresses while groping your curvy ass sent my mind lewdly off track; my free hand groping your breasts savagely over your silk woven bra.

My eyes scale your body, yet, you're too self-involved to

notice my curious glare,

If only you had seen the way I had climbed every

curvature; every slope just a batted pair of eyes before, I'm

sure you wouldn't still be sitting so comfortably over there.

Cum closer.

The bartender makes his way towards me; I motion

for him to send another round in your direction while I

fantasize about those hips,

I see you're downing a classic gin and tonic from what I

can see; you acknowledge my gesture with a smile from

those cherry-shaded lips.

Not the pair I was just envisioning—but I'll

welcome either pair so as long as they're wrapped around

the shaft of my cock, too,

Finally I decide to take a chance—I leave behind fantasy

for the painstaking truth of reality, I must get to know you.

Cum closer.

We share pleasantries, the hands of time go by as we're

deep in flirtations and in a state of spirited affairs,

"Last call!" shouts the bartender from behind the counter,

now is the time, if there ever was, to see if you'll return

with me to my debaucherous lair.

 You bit the hook; a cab ride that saw your hands

fondling my cock over these slacks that have felt so many

female fingers reach for an orgasmic release,

Your lips pressed against my own; my tongue tangled with

yours as the cabbie surely must be enjoying the free show

back here, my cock hardened as our heartbeats continued to

increase.

 Finally we were at my place, I couldn't recall

paying that voyeur of a driver; watching my hands grope

your supple tits,

Refraining from pulling out my cock in that cab and

bending you over took a toll; but now it's my turn to tease

and torture you, leave your clit engorged as the wetness

glistens upon your slit.

Cum closer.

I know where you want my mouth now; in-between

your legs, my tongue dividing both of those velvety lips

with a finger sliding in and out of your tight ass, but in

order for me to do all of what you're fantasizing, I have to

rip that dress off and bend you over the foot of this bed,

how long do you think this encounter will last?

You bite my lower lip—the pinch and sudden taste

of blood awakens the animal at my soul,

With both of my brute hands I flip you over, pulling your

dress up and thong to the side, my tongue diving deep

within your sweet asshole.

You moan so loudly—shhh! I do have neighbors

and I'd rather keep the noise to a minimum if we can,

As I tongue fuck your ass and pussy, I unzip my pants and

stroke my cock with that free hand.

"Fuck me! No more tongue—use your cock on either hole

you want, just fuck me now!" you plead,

I retract my tongue from lapping at your clit, standing

upright with my cock dabbing at the entrances of both

holes—choosing which one it'll feed.

Cum closer.

Late Night's Air

I caught the scent of your sins; through that crowd dancing

the night away,

The swaying of your hips told me of the places you've

been; places your lips would seldom say.

Raven-haired goddess—I want to take you places

you've yet to see; places you've kept confined in your

mind,

Those chestnut brown eyes—inciting an inferno deep

within me; come closer and scavenge my body for all of the

treasures you've yet to find.

Take my hand; grasp it tightly, now step forward

until our bodies press together upon this floor—below our

waists it's already been decided,

Let my hand glide in-between those luscious thighs till I

can feel your warmth; your wet, you bite your lips like a

tigress as I insert a finger—let out that roar, you and I both

knew this would happen the moment our bodies had

collided.

The saxophone keeps peppering the air with her

siren's call— but it was the alluring appeal of your

ravishing frame that echoed my name,

We should get out of this place before I find myself fucking

you in some godawful stall—your body's scent, its heat,

tests the limits of the savagery I've tamed, my tongue begs

to extinguish your pussy's scintillating flames.

I pull you away from the mob, passing a ravenous

hand over your shapely ass—I can't wait to fill both of

your inviting, teasing holes,

I see you from behind as we exit this place at long last—my

cock is aching to be set loose from its denim purgatory,

pulsating for a chance to glide into Elysium, we're just two

abandoned souls.

But we found each other tonight; or I found you, now

you're passing your sky-blue thong teasingly over my

wickedly curious nose,

Finally you pull my hardened cock from these suffocating

jeans, wrapping your legs tightly around my waist; seeking

to temper your pelvic fires with my throbbing, thick hose.

Velvety.

Steamy.

Silky.

A vice-like grip wrapped around every inch, every

vein of my swollen cock,

As I bore into you with the carnal desire; that primal rage

you stirred deep within me, I pulled out, flipping you onto

your stomach as your backdoor aches to be unlocked.

I pass my tongue over your tight asshole—your

finger finds its way over to your inflamed clit,

I align my cock towards your puckered exit—soon to be

my entrance, I ease in slowly, as it's indeed a tight fit.

A few slow pumps soon leads to you reclining back on it—

all the way till it's fully vanished deep within your

voluptuous ass,

It only took a few minutes till I came deep inside of that

tightened hole—the way you moved those hips ensured this

sexual encounter surely wouldn't last.

 I felt you cum; rubbing that clit as if we had a date

with death in less than a few minutes, the sheets stained

with our salacious one night affair,

To think of how this all began still leaves me blissfully

numb; with a simple scent that drifted farther than nature's

intended limits,

I suppose we were both savages caught up in the

animalistic desires so copious in the late night's air.

The Spider and the Fly

I met her in a bar, she was lovely to behold, her curves

seduced my lustful eyes,

I offered her a drink, she never saw me drug it, soon my

bedroom would be filled with her cries.

 We spoke about superficial things; the weather, our

favorite foods, then she began to whisper into my ears,

I asked if she would like to continue this over coffee at my

place, I used her sense of comfort to soothe any suspecting

fears.

 I knew she wanted me to undress her, to slowly pull

down that pink thong from behind,

I knew she was just using the liquor as an excuse to get

fucked, she wanted me to fill every cavity so she could feel

utterly sublime.

I intended to; my hands reached back and aggressively pulled her ass cheeks apart--she was taken aback,

I quickly threw her down on my bed, my tongue now darting in and out of her savory ass, we both knew there would be no turning back.

She moaned deeply, backing her ass into my face, my tongue reaching deeper depths of carnal desire,

He was rubbing her clit rigorously, I could sense she wanted me to penetrate her, she yearned for a hose to extinguish her feminine fire.

I did not disappoint; sliding into her inviting pussy easily, which was wet with anticipation, and hot with a primal lust,

I used my thumb to gently finger her asshole, she reached around and inserted a finger of her own as well, to her, anal sex was a must.

I felt I had met my sexual equal that night, but the voices

told me to finish what I had started—I began to pull out and

pressed it firmly against the opening to her tight ass,

As she began to grimace, I reached for the blade and

wondered which memory would undoubtedly be her last?

 As my cock squeezed itself in, she let out quite a

howl—that was my sign!

 And it was at that exact moment I brought the blade

down towards the back of her neck, she didn't fight it, her

death was utterly sublime.

 For I was the spider, and she the fly.

Two Strangers in the Night

Your index finger's tip glides across my famished lips—I

crave your body's enticing heat,

Fueling the primal urges of an insatiable hunger, I pull you

in closer by your voluptuous hips—I can feel the

palpitations of your quickening heartbeat.

Your eyes are widening; your breaths are heavy,

your body is tense,

I turn you so your back faces me; I bend you over the bed,

you arch your back as a sign instructing me to end the

suspense.

You want it as well—this discrete encounter,

reaching back to pull your thong to the side,

You spread open both of your tempting cheeks, your kinky

side surfacing—whispering to me how badly you want my

tongue deep inside.

I tease you at first; the tip of my tongue gently grazes over your clit, then dabbing at the rim of your decadent asshole, You start to grow anxious; your hands clenching the bedsheets, knowing that if my tongue doesn't dart into your pussy soon, you're bound to lose all moral control.

Finally I appease your needs; my tongue ravenously divides the lips of your moist pussy, while my finger darts in and out of your taut ass, You begin to pant, your hips come off of the bed as you fuck my face, I must pace myself if this encounter is to ever last.

My cock is throbbing at this point; wicked fantasies of penetrating both of your holes, I begin my ascension to mount your quivering frame, I align my hardened cock with the opening of your wet slit, there's a savage lust in your eyes, don't worry; soon I'll have you screaming out my name.

It slides into you; I can feel every inch of your velvet-like sheath, the sensation is surreal,

I place my mouth over your inviting right breast, biting at its nipple to excite your erogenous zones, you feel my index finger fucking your lubricated asshole, the feeling a welcoming ordeal.

You turn around; arching your back like a cat in its morning stretch, whispering to 'slide it up my ass, and don't hold back!'

Flabbergasted by your newfound debauchery for all things wicked, I place the head of my cock up against your puckered sphincter, remembering to not cut you any slack.

The first few inches meets resistance as expected as we both delve deeper into our carnal lusts; but soon we're both moaning as it fills you with every inch, your pussy is about to burst like a dam under too much pressure.

I cum in your pulsating asshole after a few hard thrusts; my limp body in an orgasmic heap over yours, just two strangers looking for a rendezvous of hedonistic pleasure.

Your cum: your pussy glazed-over; glistens like an inviting tease,
my cum: spilling out of your asshole as it recovers from the sexually charged onslaught, both of us drifting off to sleep with the scent of our sex still coiled tightly among this titillating breeze.

I can still feel the rim of your tight asshole enveloping my cock inch-by-inch . . . your warm and wet pussy like a velvet sheathing that dared to squeeze every last ounce of cum from my throbbing cock.

I'm on my back now, my erection still pointing towards the heavens, but I just fucked a demon of a vixen—who needs heaven when hell is this hot?!

Can we, will we, ever do this again?

Just two strangers in the night.

Foreplay

You're lovely when you're bleeding; crimson colored nectar
flowing down your face, such a vision on display!

Arousing my senses; I am the shark sensing your
open cut, and you are nothing more than my newest prey.

Have a seat; settle down, can I take your coat and
fix you a drink?

Feel my heat; don't you dare make a sound, tonight
neither of us shall sleep a wink.

I plan on ravaging your body, every orifice shall be
filled to its maximum capacity!

I want to see your eyes roll back in orgasmic bliss, I
want to hear you wake my neighbors with unrivaled
audacity!

And then, when you're about to cum; when the
build-up of my hardened cock sliding out of your pussy and
into your ass has your clit swollen with sexual bliss, and

you're about to release all your frustrations with the world

on these sheets, I want to stab you in the heart,

I want to see the shock in your eyes as I continue to thrust

into you while you lay there dying, I want you to pass

knowing your idea of animalistic love was callously

slashed apart.

Oh yes, now I've climaxed; a warm load leaking

from your puckered hole,

As my throbbing cock slips out of your dilated ass, on this

night, I'm convinced Lucifer is the beneficiary of my

depraved soul.

So drink, have another sip, go on, keep drinking,

lower your thong to the floor and climb aboard my bed,

Now bend over, prepare for my penetration—no, not

THAT kind, the kind that draws blood and inspires morbid

poems based hauntingly on the dead.

Would You (Let Me?)

If I saddled up behind you, delicately placing my hands over your hips—pulling you closer till your shapely ass was pressed against the hardened bulge of my crotch, would you let me inhale that alluring scent of lotus rose and sun-drenched yellow flowers perfumed along the slopes of your silky, supple neck?

Would you . . . let me?

Sniffffff

Mmmmm.

Divine—an angelic fragrance that's both; intoxicating, and stimulating where you've already stirred the interests of my darkest, most depraved of fantasies.

But underneath that heavenly aroma, an essence—a spice; an inherent zest that hides behind that gleam in your eyes, as much as you do your best to conceal its presence lacquered across your polished flesh—of a demoness lies

within you, dormant yet, awaiting to be roused from slumber.

But I've never been a saint, and as my fingers begin to skid up along your spandex black leggings—feeling the outline of your thong, the elastic waistband I want to pull down with my teeth in order to reveal these gifts under wraps—I have to ask you, because I need you to be a willful deviant in this heated sexual affair, that if I had the desire to roam beneath this cotton shirt of yours and caress your lovely breasts . . .

Would you . . . let me?

Baby, these hands—these restless fingers, ache to fondle, massage, and savagely squeeze those precious mounds below your clavicles being held firmly in place by that pesky lavender bra clasped along your midriff (but, oh-so-lucky to be smothered by such a curvaceous feast for the sexually insatiable), this white T-shirt of yours that should be on this tiled floor bunched up and at your feet, catching

the warm beads of animalistic lust as they roll off of your

nipples and slice through the tense, heated air enveloping

us within this bedroom.

The tips of my fingers flicking at your pink nubs,

pinching 'em, teasing 'em till you feel the levee in between

your upper thighs beginning to collapse under the pressure

building up in that wet, swollen pussy as your pulse and

breathing quicken.

You're flushed along the neck and those lovely

tits—don't be, I won't bite, darling.

Unless if you want me to.

But before I pull these skin-tight black leggings off

of this enticing ass and meaty thighs, I have to ask you

something, something important, because it takes two to

tango, sweetheart . . .

Would you . . . let me?

They clung to the cleft of your ass cheeks, no surprise considering mountainous peaks and valleys they were entrusted to camouflage.

I bring them up to my nose, inhaling your feminine scent and spiking my libido to a painful, throbbing summit I can't wait for you to ascend.

Your thong, a scarlet sliver of thread imbedded within those round, bewitching cheeks that leave me momentarily spellbound; bewitched, completely charmed by this carnal buffet whetting my appetites and awaiting to be bitten into.

But before I sink my teeth into your ass—any cheek will do, baby—I have to ask you something, although I'm beginning to understand you're more than willing to be a silent accomplice to the many crimes I intend on perpetrating to your body tonight, if you'll, you know.

Would you . . . let me?

Mmmmmmmm.

Each bite triggering a moan on your end, as your hips sway in a rhythm known to the sexually flustered.

The levee seems to have broken, 'cause I can see, from my bird's eye view back here, that your pussy is wet along that velvety slit burning with desire right now.

She's on fire, huh?

I should extinguish those flames . . . with my tongue, no?

You look back at me, swiping strands of your hair out of your eyes and behind your glassy shoulders, I can see, behind those irises of yours, a hellacious color beginning to burn as brightly as any wildfire this world's ever seen.

Something beginning to possess you, should I call Father Karros?

Hell no—you don't need an exorcist as much as you need to be fucked, and there's nothing devilish about ditching your halo for a set of horns tonight, baby.

You reach behind with both hands, grabbing the curls of my hair and pulling my face in between your ass cheeks, grinding my nose, mouth, tongue and chin along those tight, warm, and wet holes.

You loosen your grip, allowing me a chance to breathe (not that I would mind being smothered to death in this fashion, hon) and tell me to pull your thong off—with my teeth.

I don't ask anymore, I simply know what has to be done here.

I bite into the red apple hue of that waistband coiled round your hourglass shaped hips and, with both of my eyes fixated on this gorgeous ass in front of my face, slowly peel the string down and out of these mouth-watering cheeks.

While you panted, impatiently waiting for my tongue to formally introduce itself to your puckering holes, I took a deep whiff of your thong's gusset, where your

pussy had been cradled till she was ready to be a big girl and lose the chaperone, and then licked it.

Tasting your pussy's juices, coating my tongue in your demonic discharge.

It turned me on.

I placed it on the floor, took both free hands and dug my nails into your ass cheeks, spreading them far apart so I had a good, unobstructed view of where my tongue would slide, swirl, and skim across.

I wanted to tease you at first, blowing hot air, softly, at your pussy from behind.

Taking cat-like licks at the rim, despite DYING ON THE INSIDE to simply slide it all the way inside that crinkled, pinkish asshole.

Still, foreplay helps create a most memorable, soul-rattling orgasm, so let's pace ourselves, darling.

Relax.

But then, with frustration creeping within you, my tongue divided those satiny lips below your navel, tasting the inner and outer folds of your pussy, sinking deep—savoring you as far in as the length of my tongue would allow—and resurfacing to lap at your red, swollen pearl-shaped clit.

Your breaths heavy, your feet fidgeting, your legs dividing as if they were being pulled apart by invisible ropes, and my tongue sliding from your pussy to your asshole, co-mingling with the sounds of my hands smacking this ass of yours.

Spank! Spank!

Handprints across both cheeks, red, tell-tale signs of our uninhibited rendezvous tonight.

Your hand comes around again, in between tongue fucking your ass and pussy, I see you stick your index finger out and begin to rub your puckered asshole. I hear you moaning, and then telling me to lick your clit.

Your index finger sinks into your asshole, fingering it knuckle deep—you're such a naughty fuckin' girl, aren't you?

My cock is aching to be released from its denim purgatory.

My tongue is swirling around your clit, rolling like a wave along your labias, till my mouth fully seals itself along that womanly delta of yours—the apex of your femininity, and I feverishly eat your pussy as your finger continues to fuck your asshole senseless.

You coo for me to stand up.

My cock's rock-solid, veiny, pulsing and hotly anticipating either hole of yours wrapping itself around the head and shaft with a vise-like grip, trying to milk it dry before we're the ones left here tonight dehydrated and exhausted.

You slide that finger out of your asshole, a soft pop fills the air as the finger exits your backdoor, and a slight

gape lingers back there—as if inviting me to dilate it
further if I dare try, if I just align the head of my cock with
the dime-sized opening of your stretched-out rim right now.

I reach for my cock, my right hand steadying it, my
left hand attempting to bring your ass into a perfect arch so
as to connect us swimmingly.

You reach behind with both hands, spreading your
cheeks and giving me more room for error.

But I don't need it—the tip eases in, the rim of your
asshole curls itself (slowly . . . let's savor this moment)
around the head of my cock, till the entire shaft is
swallowed whole; devoured, by your hungry ass.

I had wanted to feed it since I first laid eyes on it.
You rock slowly back, taking in as much of it as there is,
till my balls were pressed up against your wet pussy.

Oh. My. Fucking. God.

We're not in church, but here you are calling out the
Creator—the Master Craftsman—as rock-hard cock stirs

deep in your rectum, and a hand reaches around desiring to rub your clit to a creamy orgasm.

Full, twenty-four hour tilts of my index and middle fingers massaging that engorged clit of yours, as your asshole clenches and spasms sporadically along my shaft with every forward thrust from my hips.

I use my free hand to pull it my cock out completely, rubbing the head along your wet, gaping rim just to tease you.

You try backing into it, but I pull back. Frustrated, you bounce your ass up and down as if pouting for something I refuse to give you: a hard anal fucking and creampie.

I had an idea you were kinky, and somewhat deviant.

But before we tread this road—because not many ride along this path, my perverse pet—I have to ask you

something, while you maintain your position right there

bent over, cheeks spread . . .

Would you . . . let me?

No Ordinary Love

That Night was chilly, nothing unusual 'bout a December Evening in the Big Apple, darling.

But in that room with you, the sheets spread underneath your soft, exquisite flesh, the idea of making love to you lit a wildfire within my soul.

I desired you like a man crawling along the desert on all fours, his throat dry and aching to quench a thirst that could only be satisfied by lapping at the wet pearl hidden between your legs.

How badly I wanted to bury my face in your honeypot, indulging my sweet tooth.

Your fingers and nails digging into my curls, pulling my head closer, my tongue deeper, with your legs splayed open welcomingly, your moans a blissful hymn in this devilish apartment of sinful decadence.

This wasn't an ordinary love.

No, no it wasn't.

I remember my hands finding themselves towards your curvaceous, beautiful breasts as I tasted your warm, creamy pussy as if I hadn't eaten for days.

I wish I had more fingers, because ten felt like five when you had given me two mounds of milky white flesh to touch, hold, grip and grab to the desires of my sexual appetite.

I heard you moan, before you pulled that thong off and my mouth hovered eagerly just to the inside of your upper right thigh, gently kissing your natural pelvic voids where your wet, soft pussy lips were hidden—for the time being—by a thin sheet of black satin that should've been in my mouth.

But you couldn't wait on me any longer, so you raised your lower back off of the bed, and pulled it off feverishly.

Not soon after, I was eating dessert.

After my hands had felt those sexy tits to their liking, they came for your round ass.

My tongue now circling your pussy, teasing it, mouth blowing hotly, invitingly at your clit as your hips squirmed in frustration.

Your asshole teasing me, baiting me into pulling you by the hips, bringing your pelvis to my face, where I'd have no choice but to pull your legs back just so I could easily tongue fuck both of those tight holes.

But your solution was a simple one: bend over.

As soon as you did, my tongue started its descent at the tip of your clit—I bet I caught you by surprise, huh?

You thought I was going to start at the crack of your ass?

No, let's keep it unpredictable, darling—and, after a few flicks and licks, I brought it up towards your sweet asshole.

Hands on both of your ass cheeks, I spread them apart wide enough so as to have enough room to get my face in there as much as humanly possible, because I wanted to ensure I could get all of my tongue up that luscious ass, swirling in a clockwise motion inside that pink, alluring little hole of yours.

I tongue fucked it till my cock, hard with ecstasy and swollen with lust, was pleading with me to end the foreplay—the appetizers—and indulge in the main entrée.

But Jesus Christ, I could've stayed there for hours lapping at your clit and asshole from behind, spanking that ass, digging my nails into it, fingering your wet holes till you'd burst in my mouth something sweet and creamy.

So much passion, and my cock hadn't slid inside your pussy or asshole . . . yet.

This is no ordinary love—isn't that what Sade sang 'bout?

What the poets write 'bout?

Love, lust, sex (animalistic, sensual, or simply emotionally and spiritually gratifying as we twine our souls with our lover's), passions of the heart, body, mind and soul . . . we wrote a chapter with our bodies that night, didn't we?

Take my hand, let's write another.

This story hasn't ended, sweetheart.

It's just begun.

An Endless Summer

Tell me that these moments are endless—even if it's a lie,
because the truth is something I've grown terribly familiar
with; it *does* have a timeframe, and, as much as it seems
we're in the throes of nirvana, within each other's arms,
I've seen how easily a lover's embrace can loosen.

And I've fallen too many times before to know
what'll be left to piece together should it happen again,
snapping jigsaws back into place in hell, where darkness
blinds all, probing the littered grounds on all fours with
manic fingers, hoping to find fragments of what you've
lost.

That must be why so many that do make it back up
to the land of the living, hardly ever come back the same as
when they had fallen.

I want an endless summer—tell me you can give me
that.

Tell me we'll watch all kinds of movies at the local theater when the weather gets hotter; summer blockbusters with Cherry Coke, M&M's, nachos with spicy cheese on my lap, and I'll even deal with that mandatory "annoying baby" that's somehow brought into any movie, at any time of the day.

I want an endless summer.

So, tell me, is that something you want? Something you can give me?

Can we share a plastic, rectangular container of stale nachos and spicy "cheese"?

I'll even feed you some, promise.

I want to kiss those bubble gum lips of yours, squeezing that ass of yours hard, pulling your hips in closer, so you could feel the bulge within my jeans that you inspired, a devilish arousal, your angelic innocence the catalyst for such deviant fantasies.

So, tell me, can you give me that?

Can you give me an endless summer?

Where sunsets inspire lustful, passionate bouts of lovemaking underneath flimsy sheets made of cotton, heightened breaths, quickened pulses, throbbing instruments of sexuality anticipating to merge as one; a musical duet, filling the air of that warm room with a cacophony of moans that are as sexually charged as any sax you or I have ever heard.

I'll hold your arms down by the wrists, sliding in and out of you from atop, swiveling my hips like Elvis, feeling every inch of your velvety sheath; her warmth, wetness, wrapped along the hardness of my cock, squeezing him with the hold of a vacuum . . . perfect fit.

So, tell me, can you give me that?

Can you give me an endless summer?

And if I turn you over—so your ass reminds the heavens (and all the angels that'll turn away shocked and flummoxed at your mountainous mounds of carnal

delights) you're just as much a demoness than a cherub,

will you let me bury my face deep within those curvaceous

cheeks?

I'll lap at both holes, don't act surprised—you knew

I would.

You knew very well I had fantasized of it;

daydreamed of this moment, wished to have this blissful

encounter climax into an endless summer.

But sex also has a timeframe, and I need more than

something tangible.

What I need is you.

What I need is an endless summer.

It's been promised by others before you, which is

why I can't put much stock into words anymore.

I prefer actions—they always speak loudest.

The sun will set soon, the moon shall rise in its

place, and the stars will dot the skylines like glimmering

diamonds waiting to be plucked from the dark expanses that is their home.

Feel that chill in the air?

That's winter coming, hon.

If you stay out here long enough, alone, it'll chill you to the bone and freeze your heart, too.

It'll numb you, trust me.

There's parts of me that'll likely always remain frozen solid.

But something in your eyes . . . your smile . . . the way your fingers touch my skin and know where to go; leaving tracks of warmth, thawing those roads your hands skidded across.

But I need more than that, and Old Man Winter is blowing sheets of snowflakes across the city skylines, isn't there a place we can go to avoid what's coming o'er the horizon?

It's time for you to tell me . . .

Can you give me an endless summer?